The Little Book of Talking Birds

ARTHUR WAYNE GLOWKA

Copyright © 2014 ARTHUR WAYNE GLOWKA

All rights reserved.

ISBN: 1495426807
ISBN-13: 978-1495426803

DEDICATION

For Travis Cown and all my friends on Facebook

ACKNOWLEDGMENTS

Thanks go to Amy Zipperer for encouragement and advice. The photographs in this book were taken with a Nikon CoolPix L820 and edited with iPhoto on a Mac Book Pro.

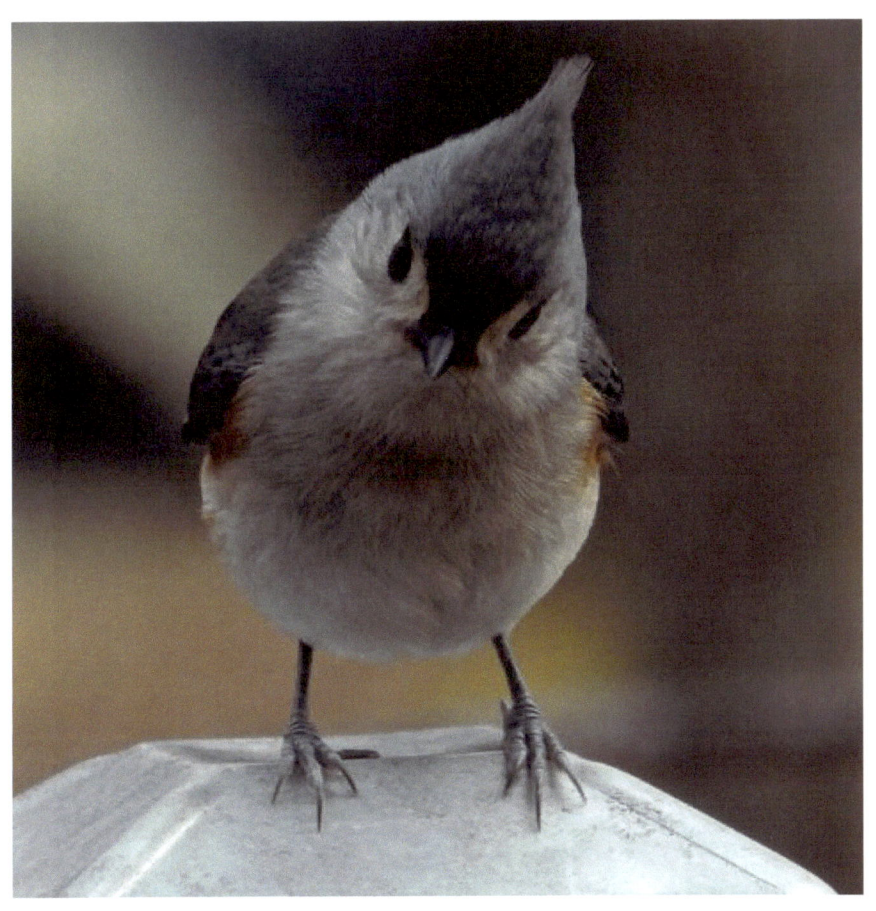

I'm sorry. I'll do better next time.

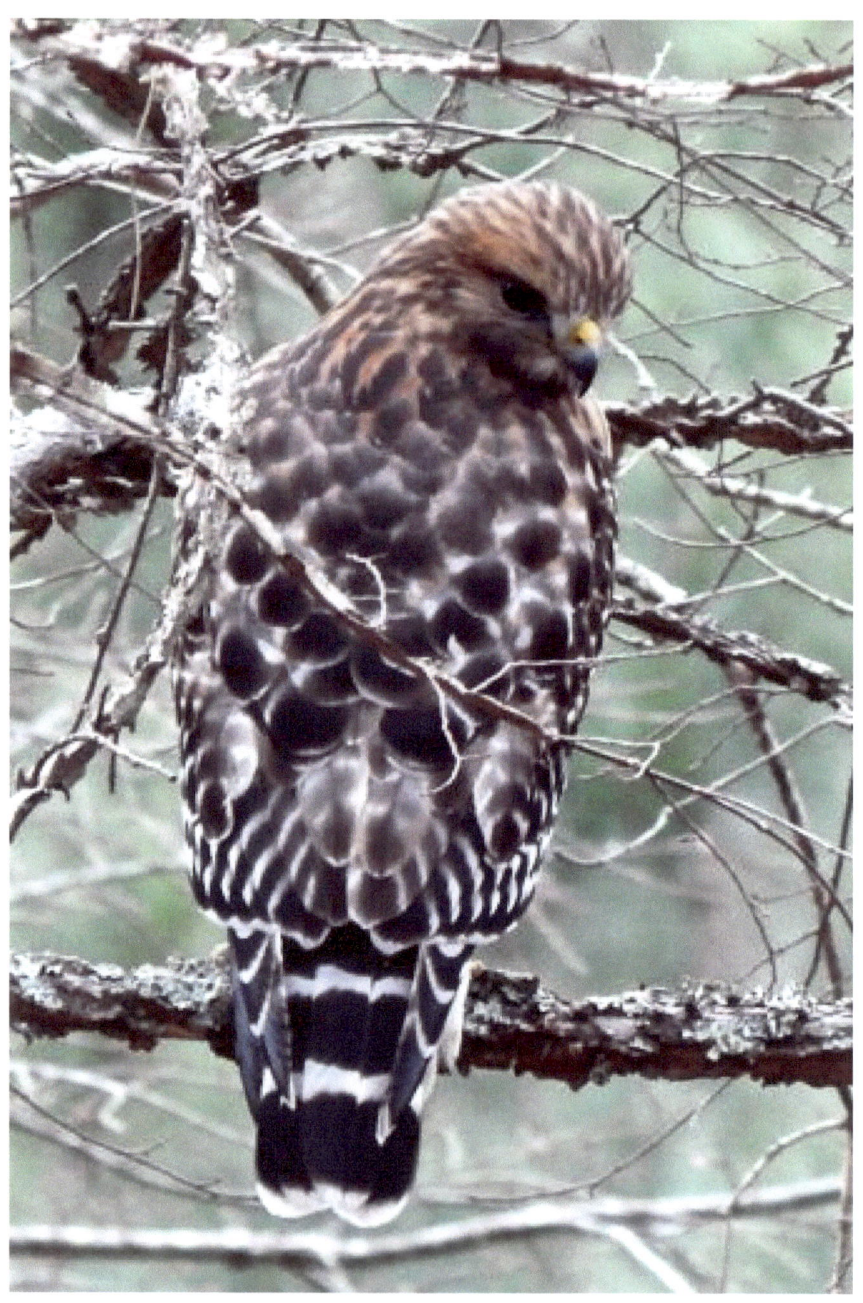

There is no bluebird on my shoulder.

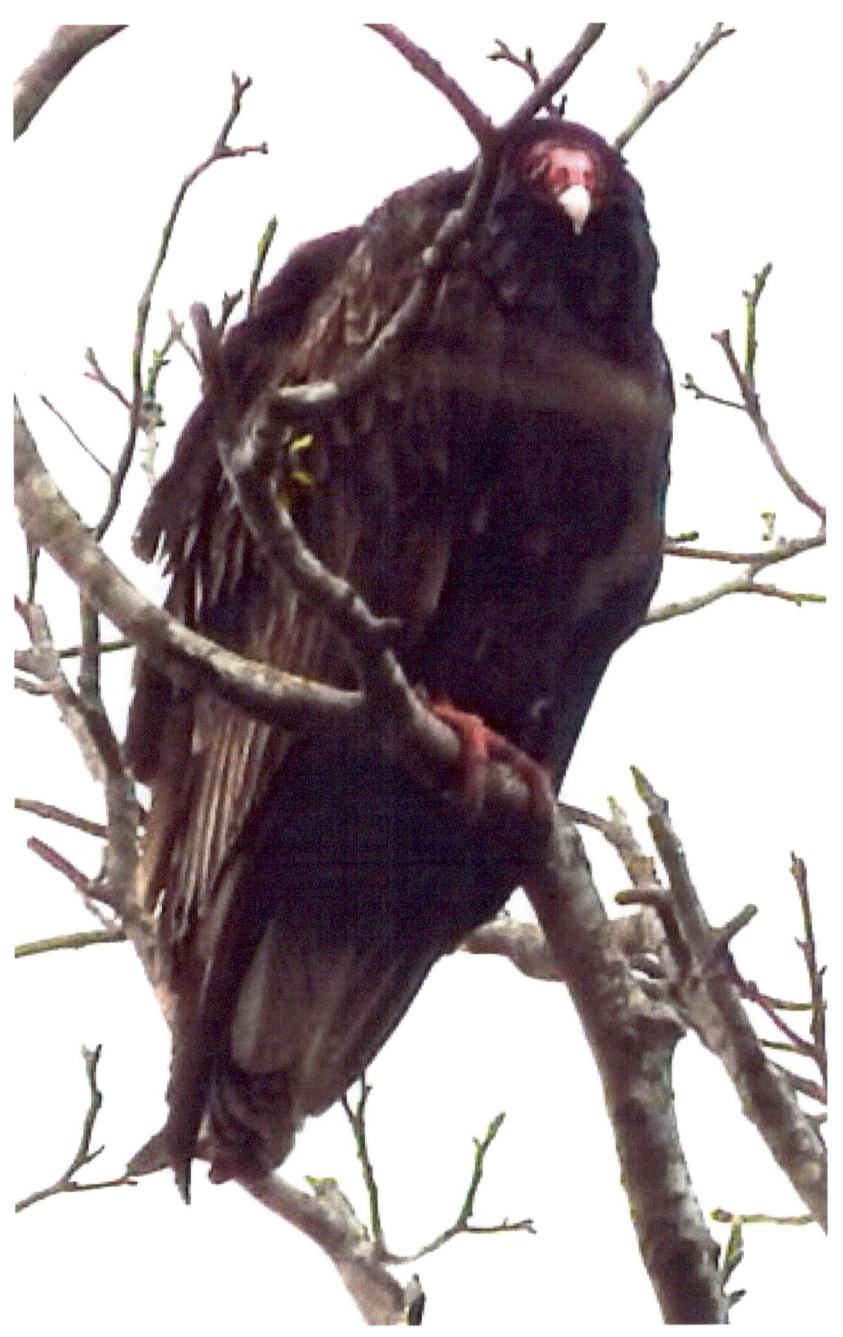

Right, I never eat sandwiches from convenience stores.

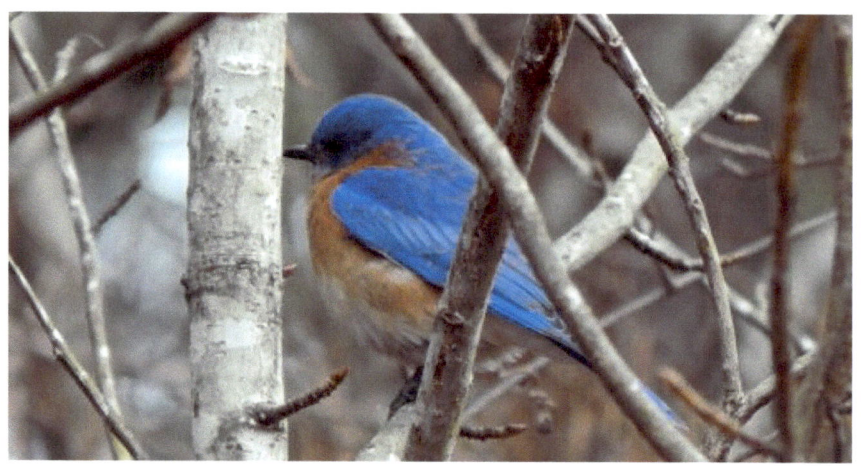

Sometimes I get so mad I turn blue in the face.

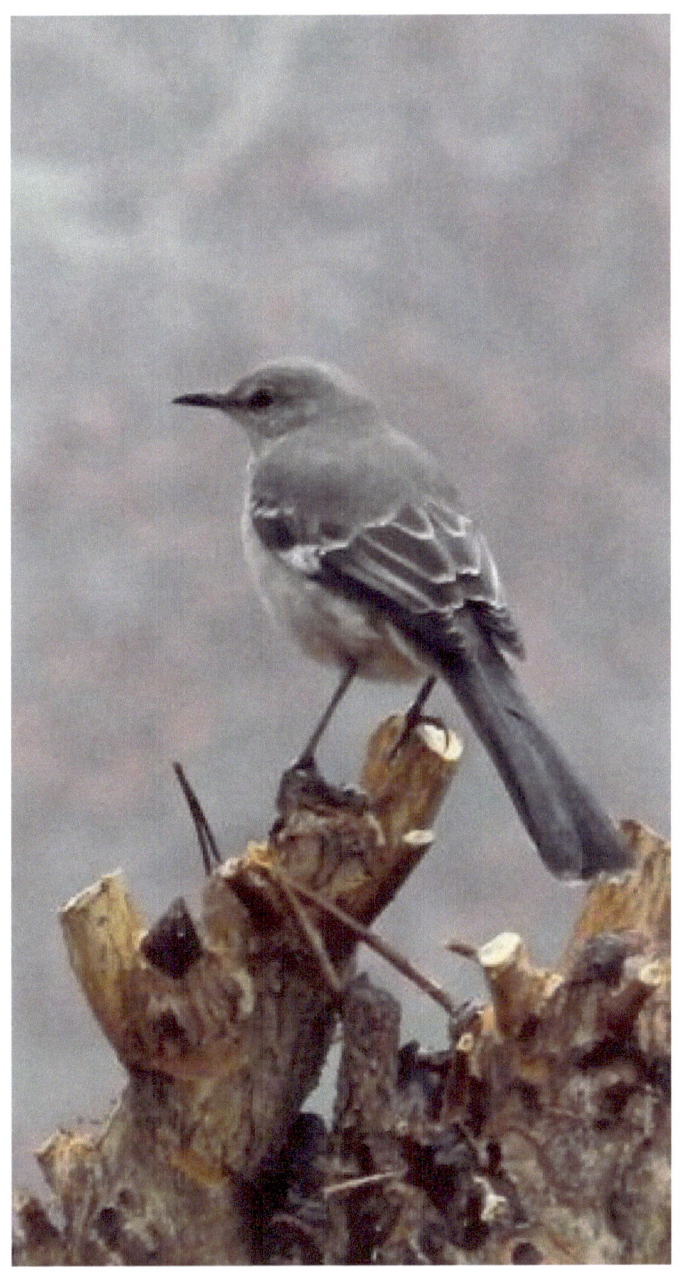

Well, you go ask your momma to buy you that ring
'cause I ain't singing in no fog.

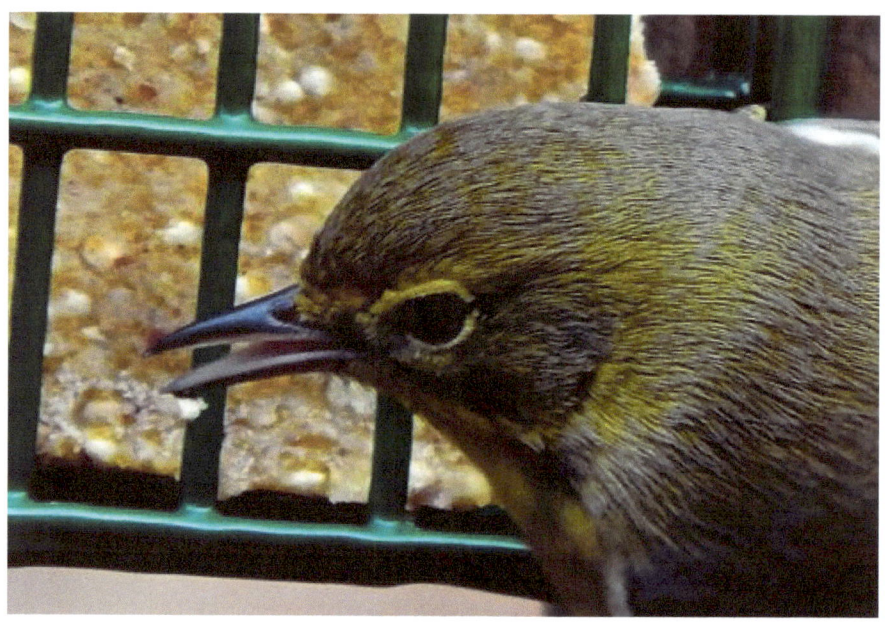
Look, I keep my nose clean, and I never suet the small stuff.

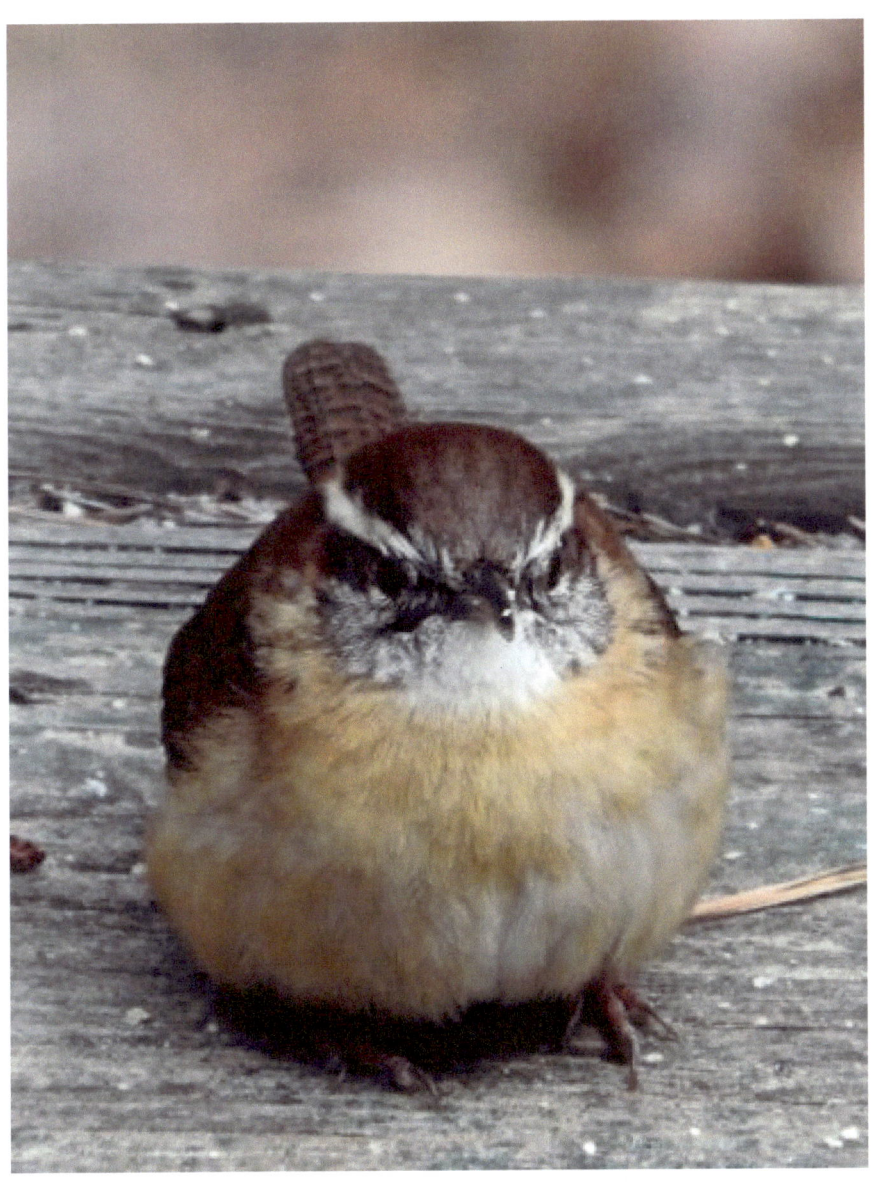

No, I did not eat all the cookies.

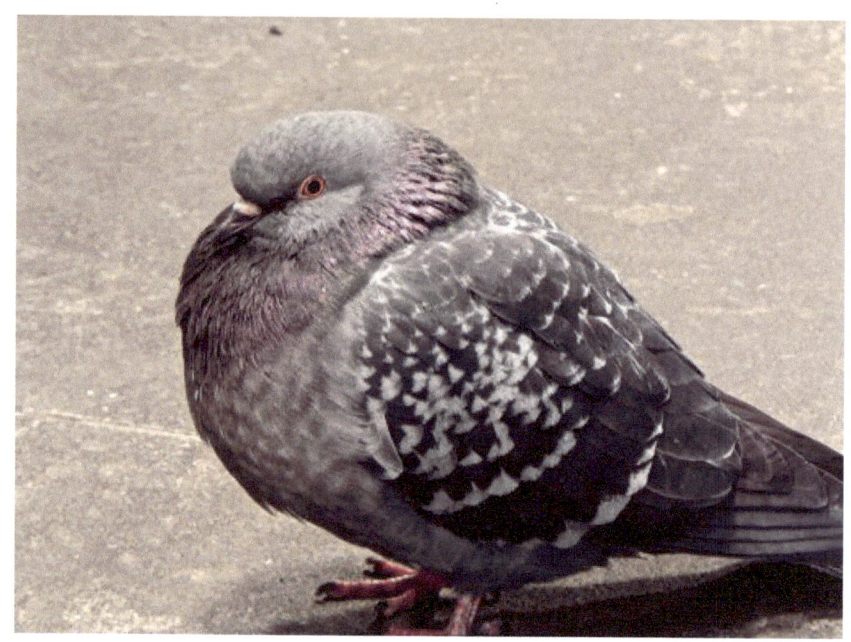

Excuse me, but bell peppers always make me burp.

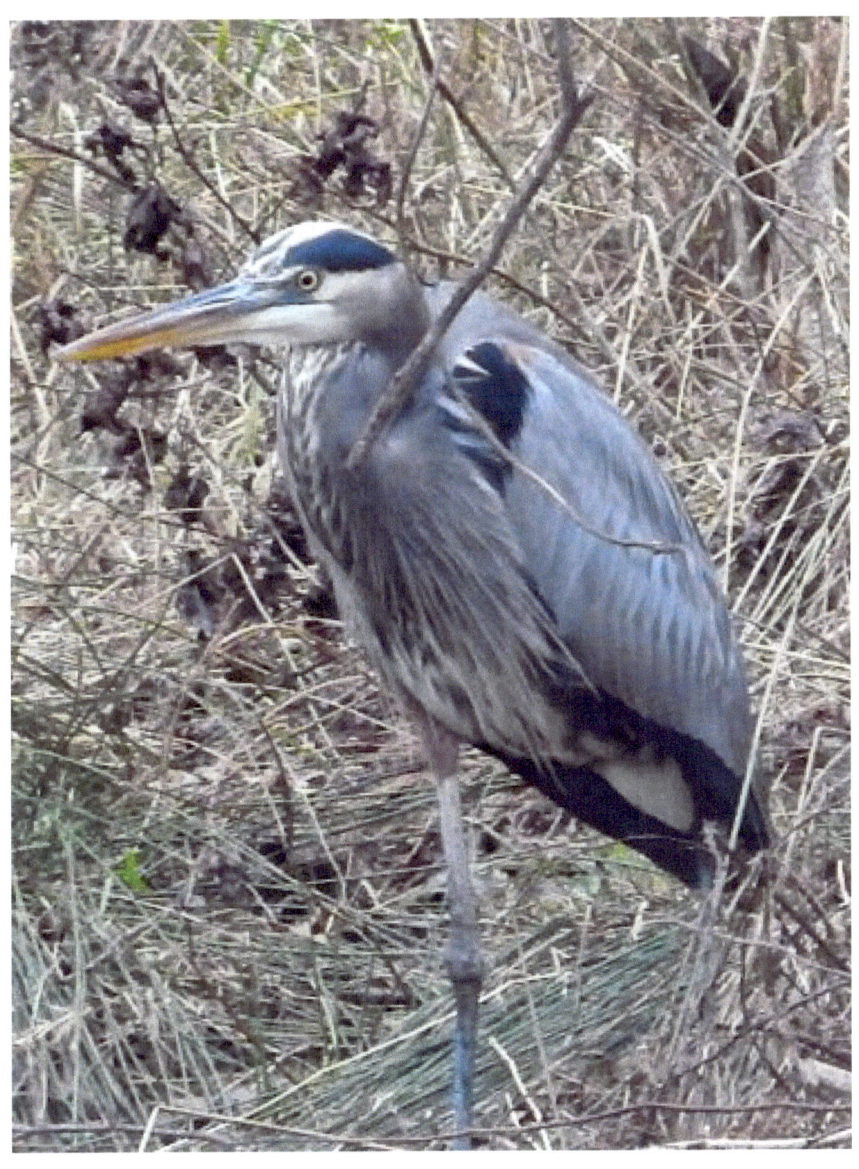

And just what are you looking at?

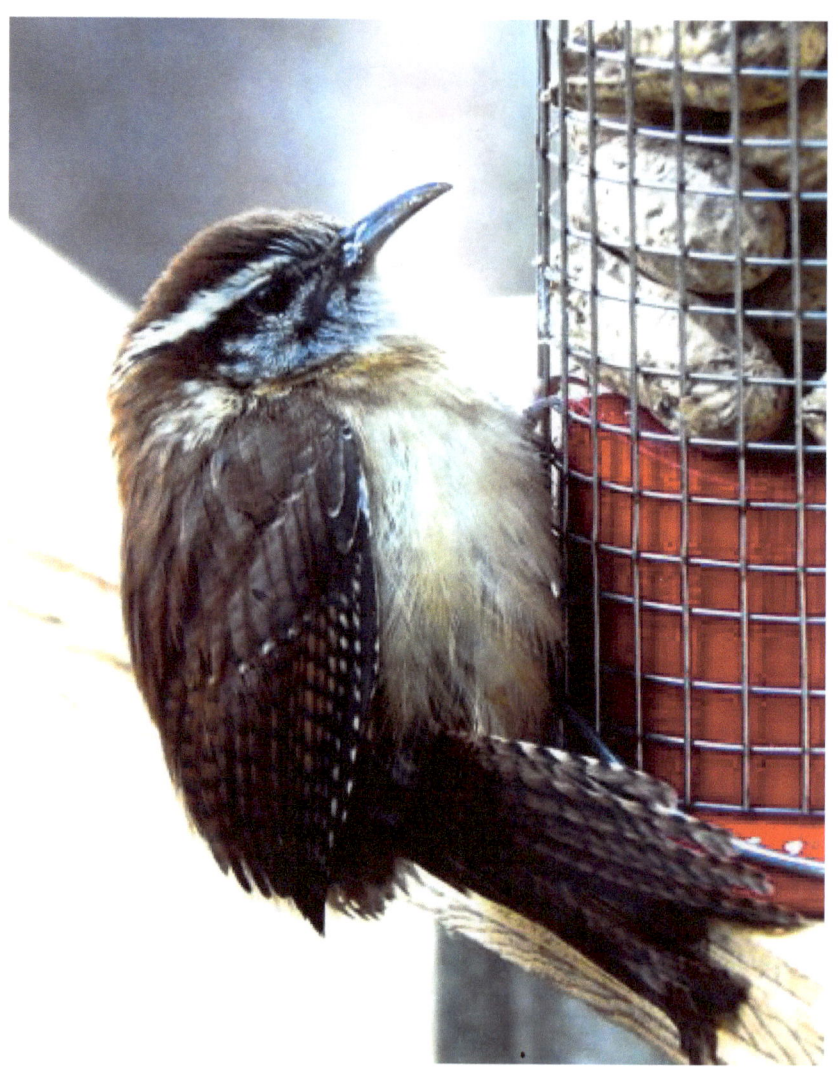

Will I work for peanuts? Do I look like a circus elephant to you?

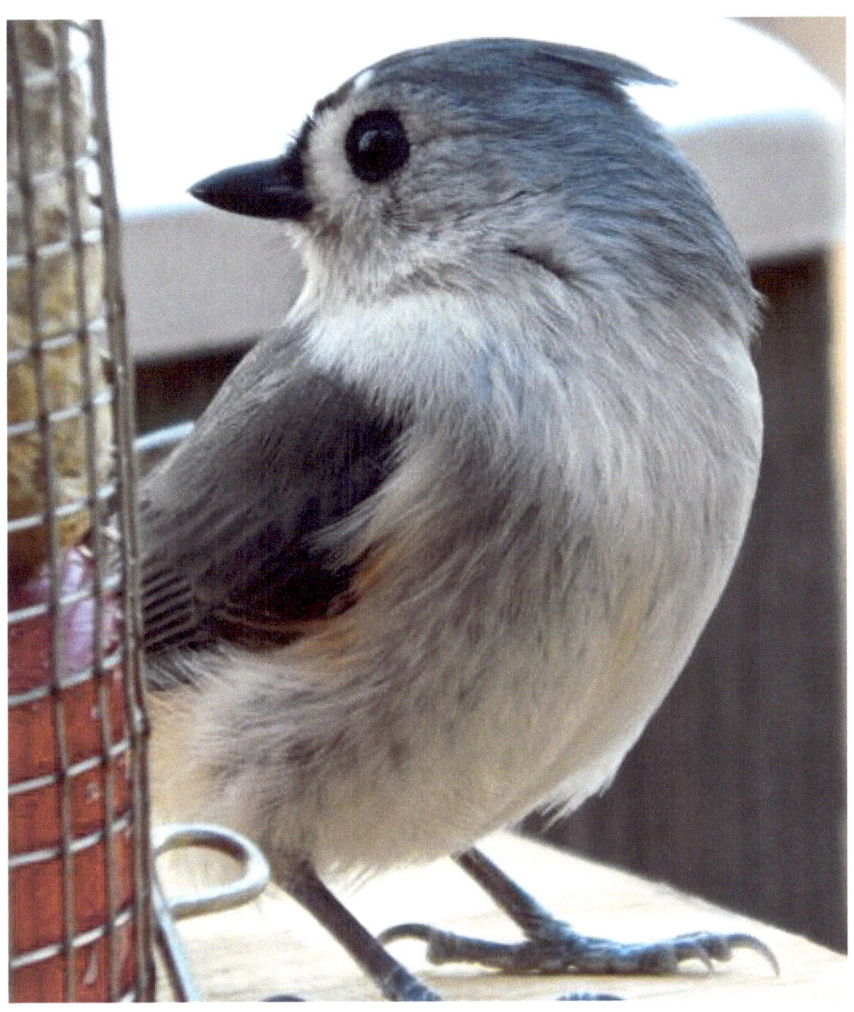

Yes, do you like it? The barber called it a duck tail.

Give me an "ess!" "Ess!"

Give me an '"el!" "El!" What's that spell? "Ess-el"

No, I am not a penguin.

What do you mean I don't have a leg to stand on?
I have two, thank you.

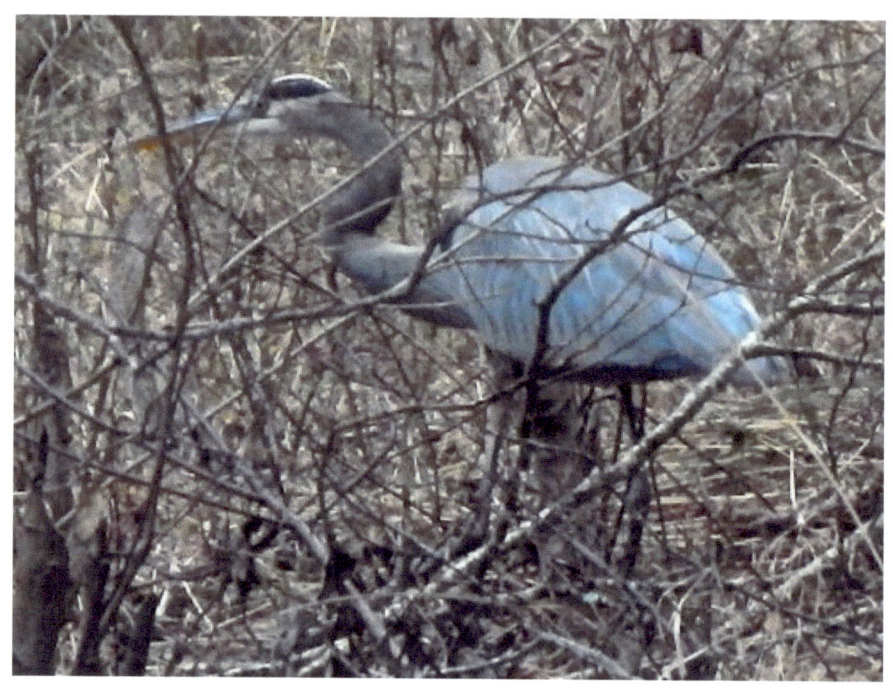

I know I left my keys in here somewhere.

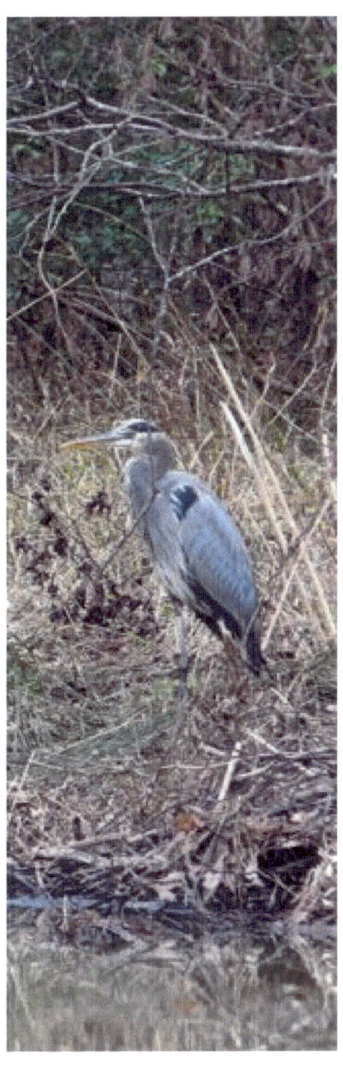

I can hear my father now: "All that education, and you got a job posing for an oriental wall hanging?"

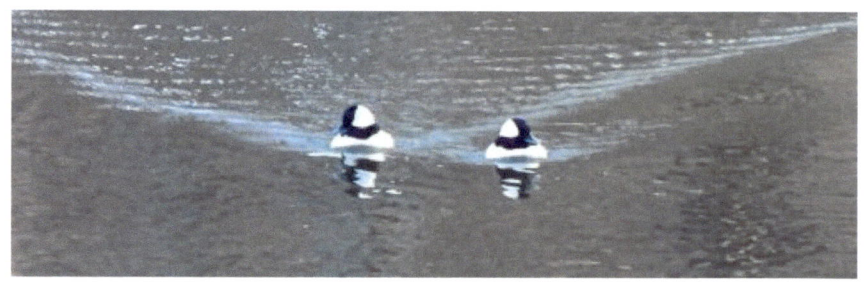

Here we come!

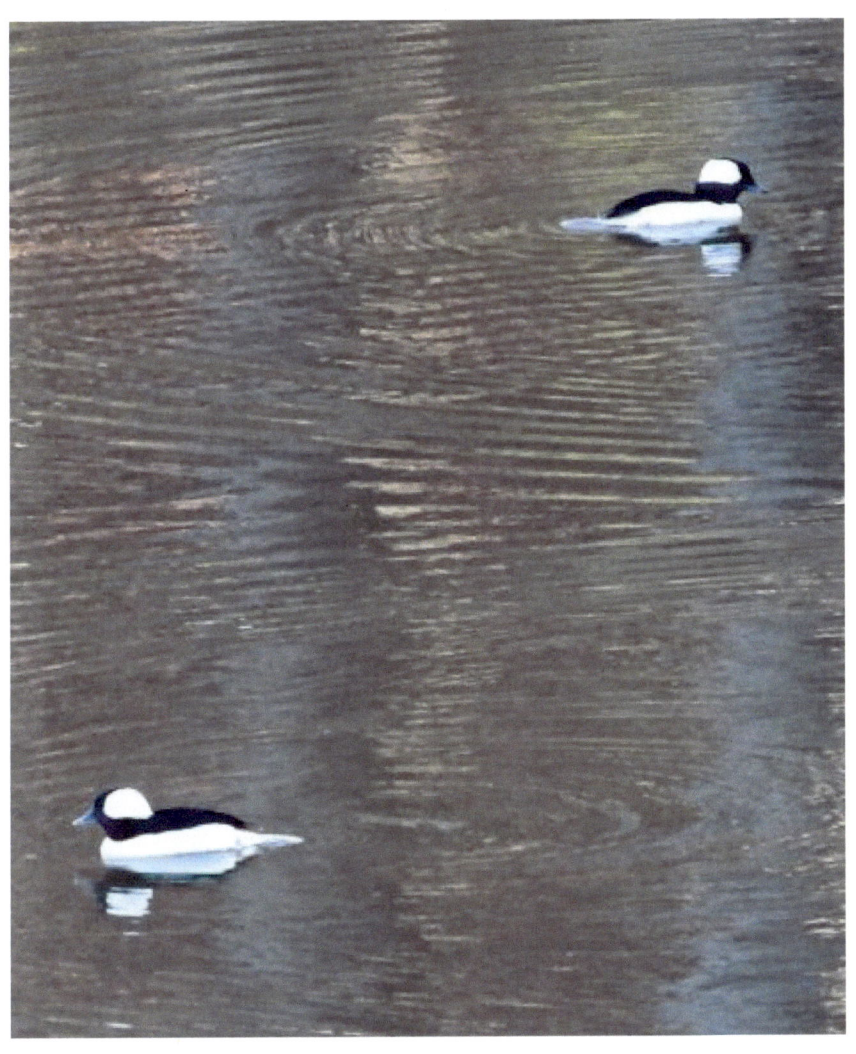

There we go!

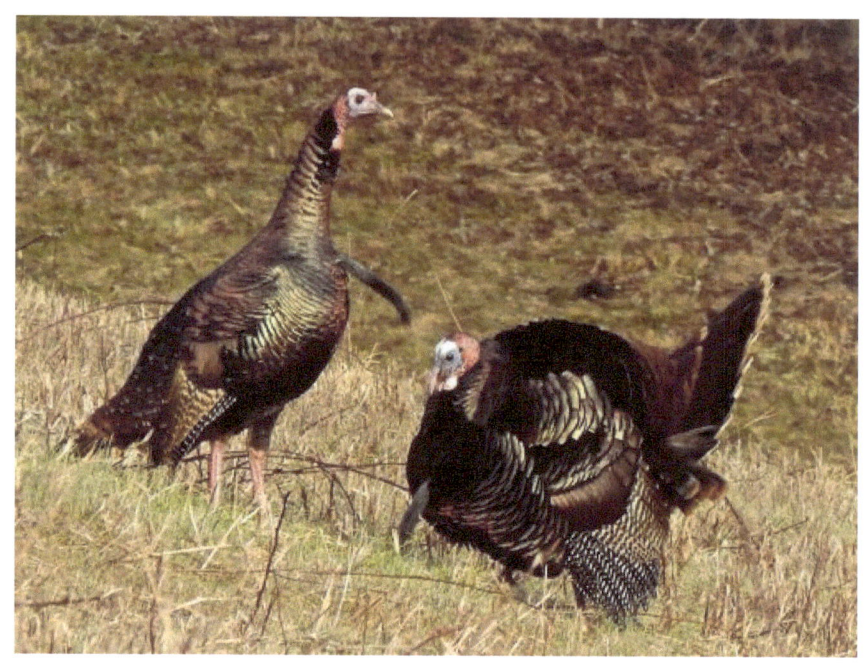

Get your beard out of my face! I saw her first.

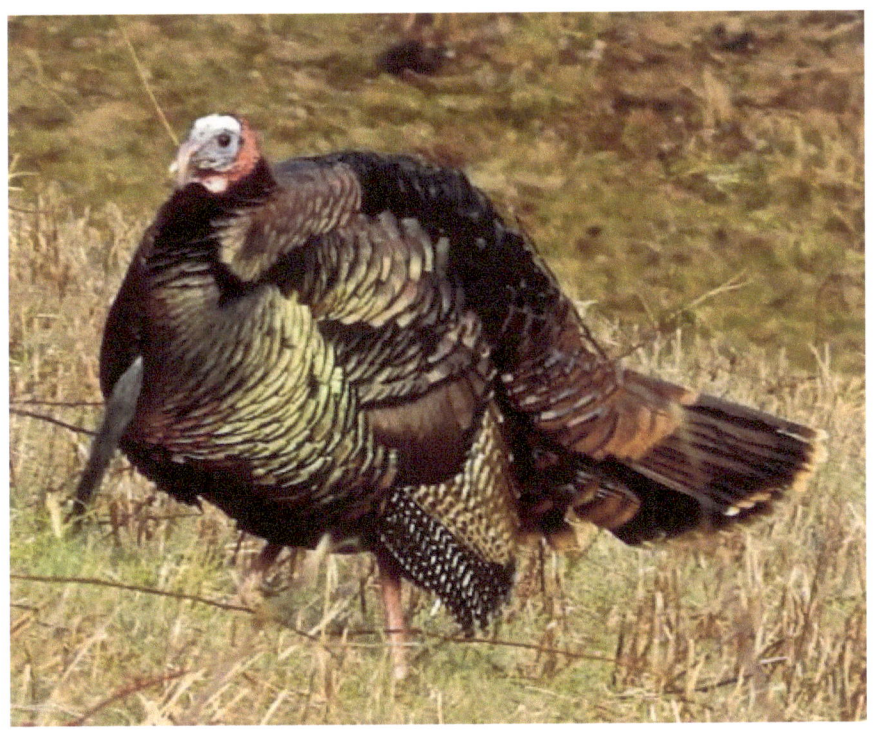

They eat what? When? No, I'm a sparrow, just a lowly sparrow.

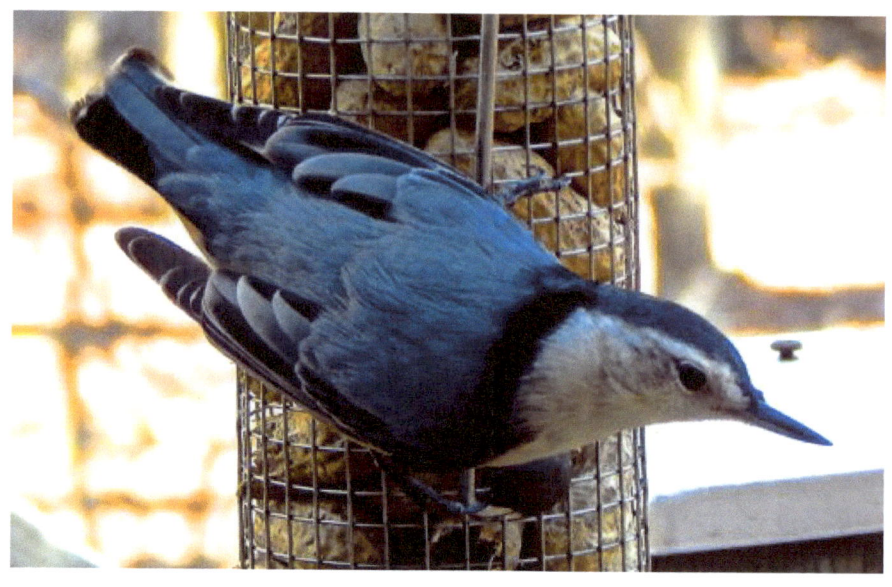

The Blue Angels? Did someone say they needed volunteers for the Blue Angels?

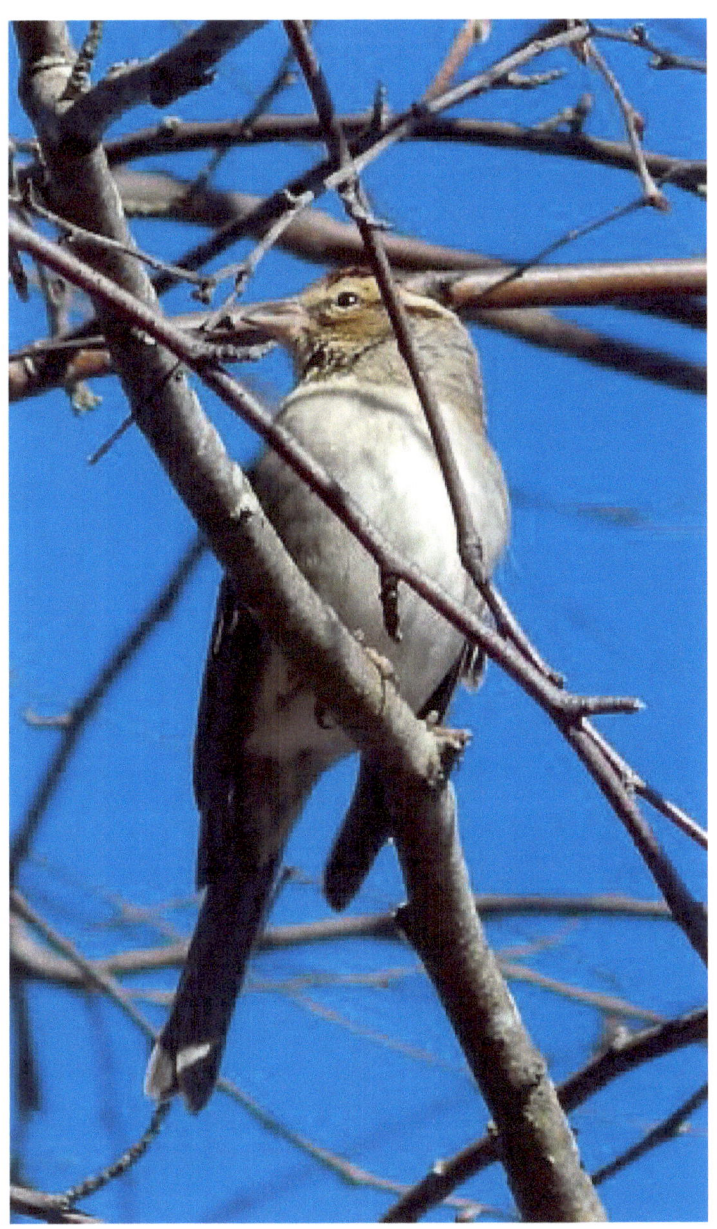

Of course, I look good in blue. Who doesn't?

Come on, coach. Put me in.

Let's see. Do I jump first or flap first? Wait—wait.
It'll come to me in a minute.

OK, so go ahead and tell me I'm cute. Then tell me how cold it is in there with the thermostat set on 68.

I'm not fat. I'm fluffy—and cold, really cold.

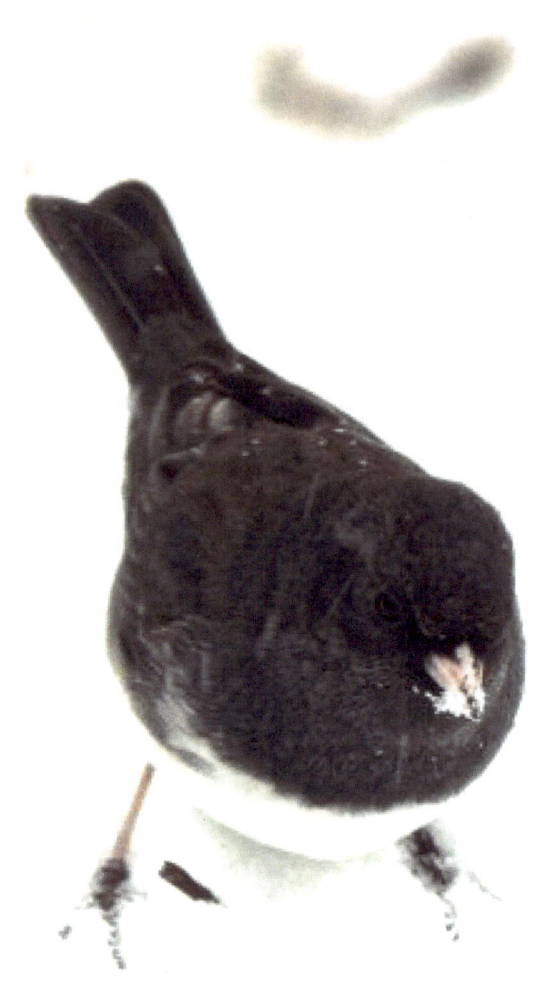

I do keep my nose clean; honestly, I do.

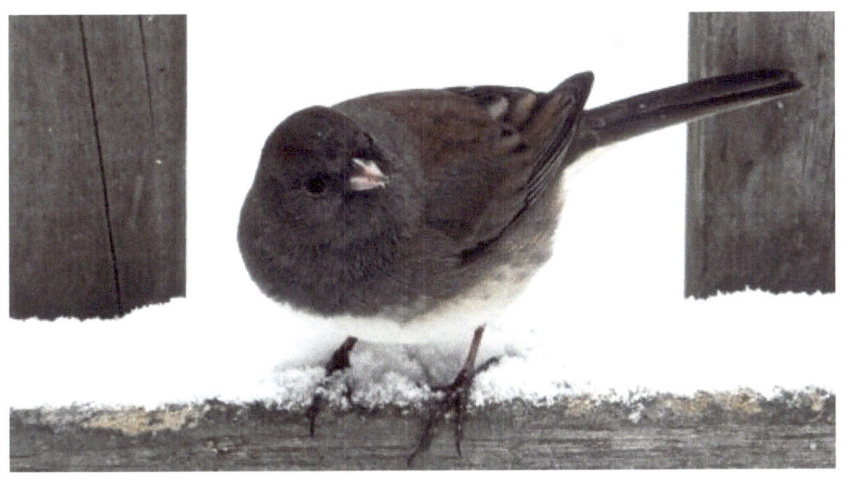

The square root of 279? Let me see. If the square root of 2 is....uh, but the square root of 27 is approximately....

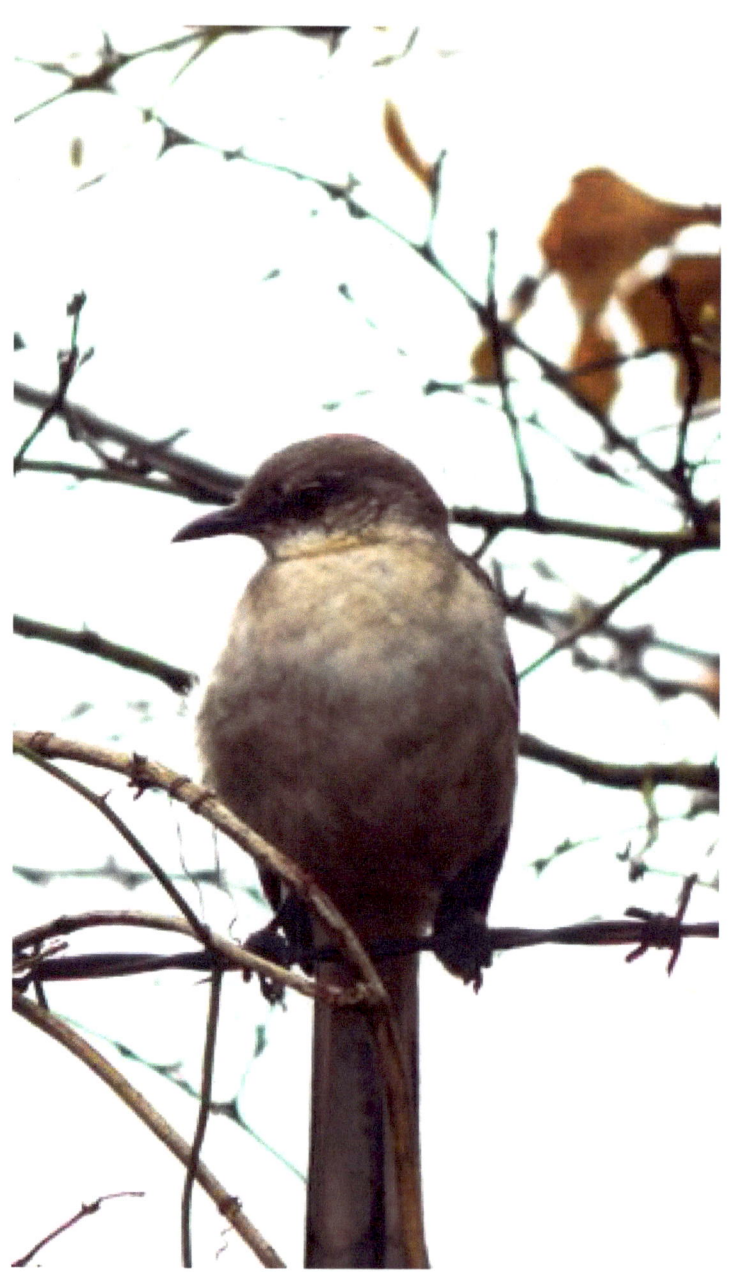

Fences? We don't care nothin' about no fences.

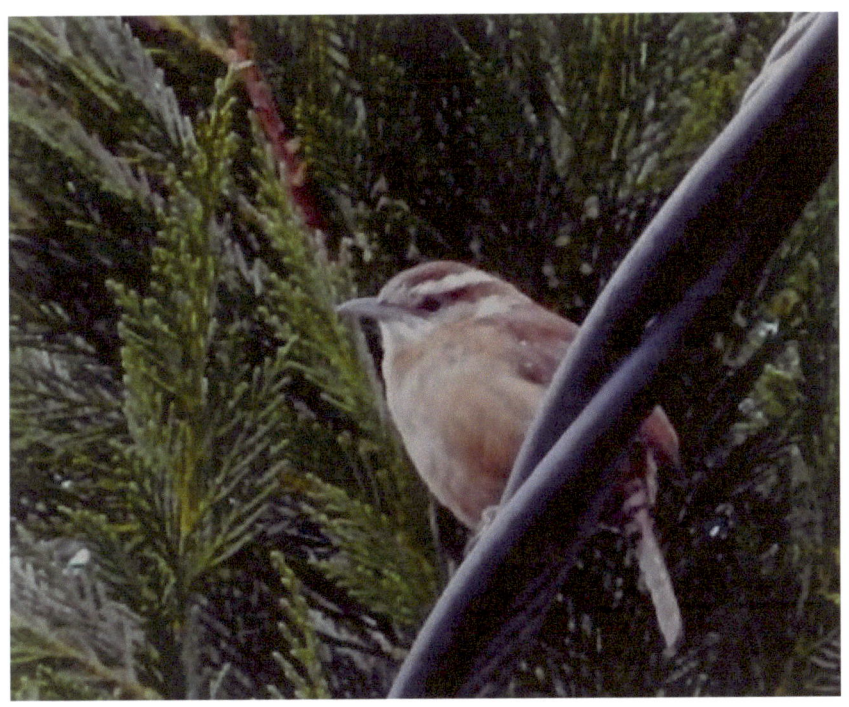

This is where we draw the line.

Yes, I had my portrait done by some guy named Monet.

Hallelujah! I shall rise on that great morning!

Uh, this is like my gum ball, so move it before I have to tear you limb from limb.

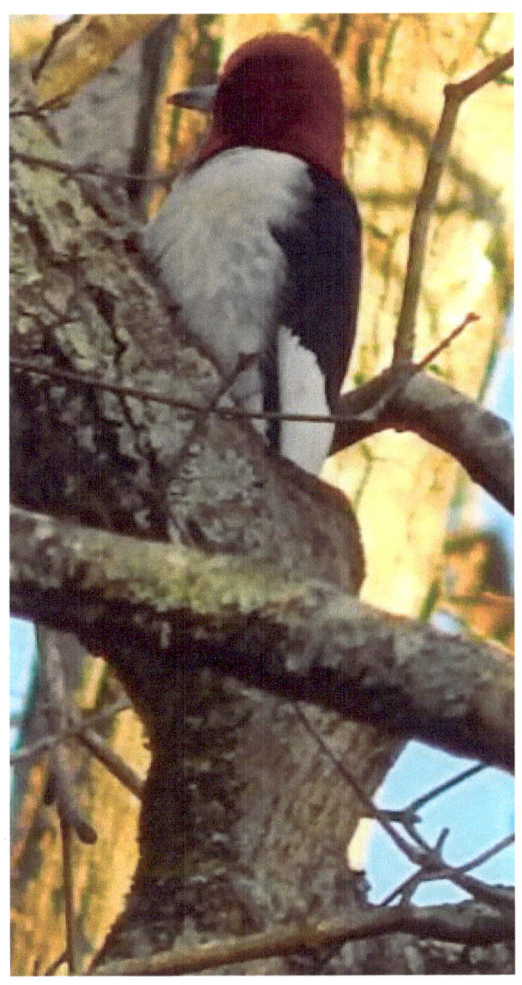

Whoa, my head!
No more red liquor for me.

Kashi with friends? Sure, I can dig it.

Uh, wouldn't this be better with like whole milk and a lot of sugar?

Another day stuck out here in the sticks.

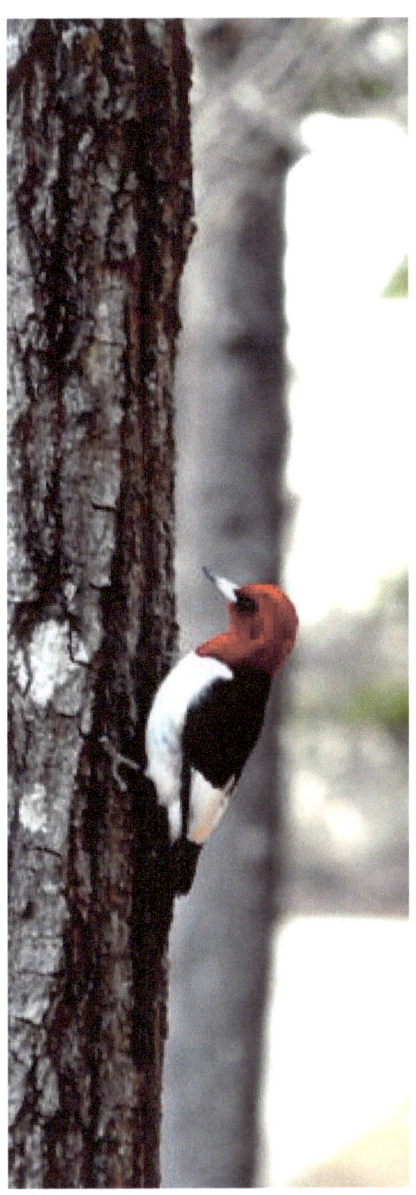

Has life got me up a tree? Brother!

Shoot, yeah, chicks really dig on camo.

You're wrong there, brother.
Chicks dig on mousse and stripes.

No, seriously, I think I'm in the wrong book.

Me too, but the food here is great.

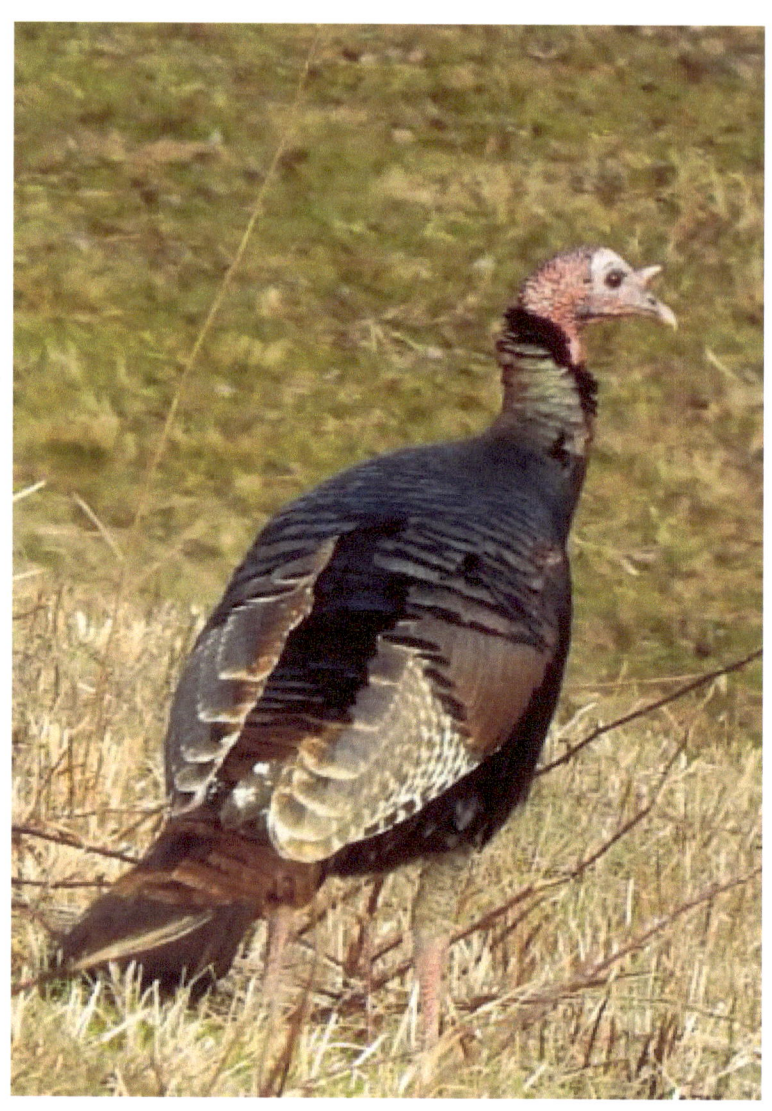

Sunscreen? You think I got a tan
like this using sunscreen?

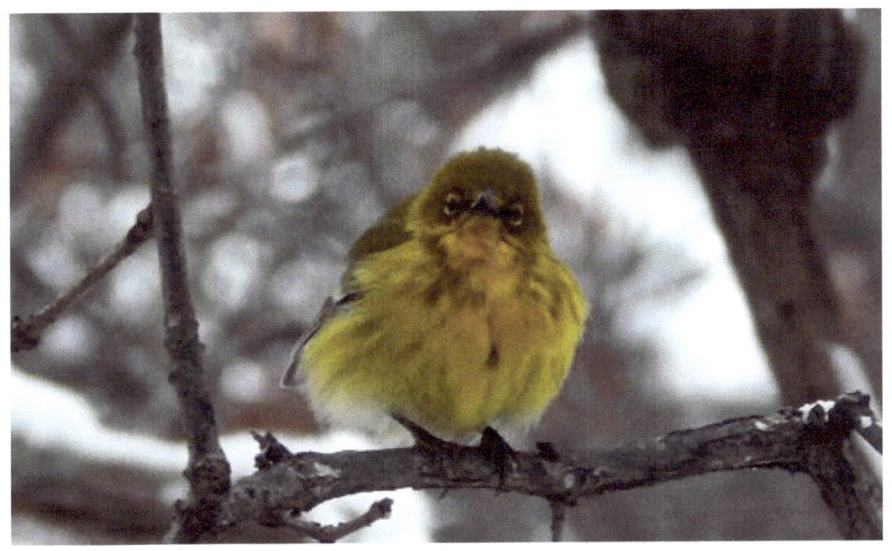

Yeah, you're a real turkey all right. Where's my coffee?

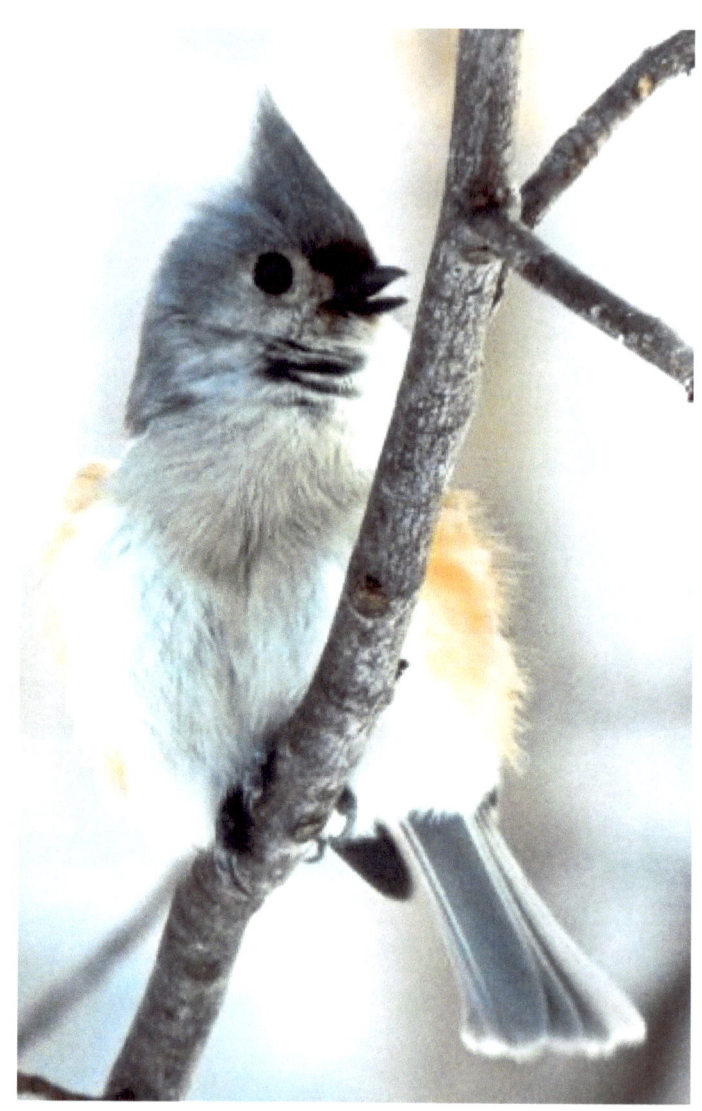

Yes, we'll sing in the sunshine.

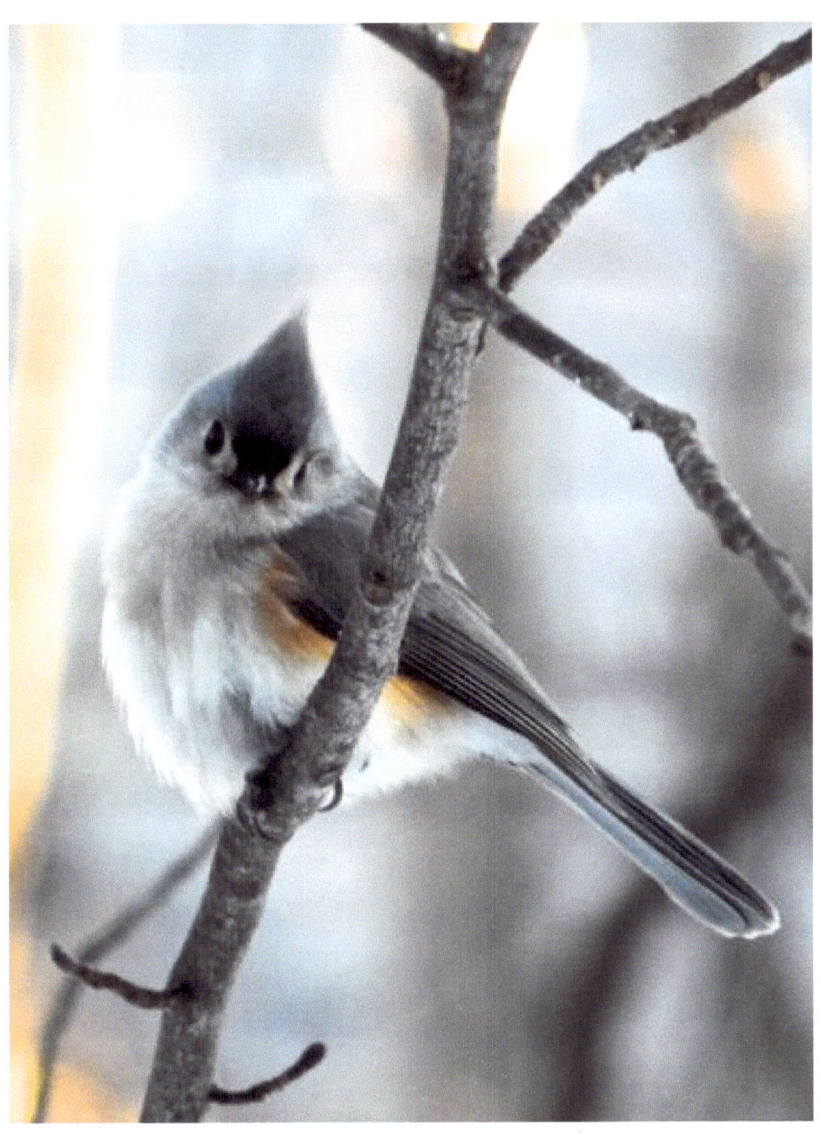

Aw, you're so cute when you look at me like that.

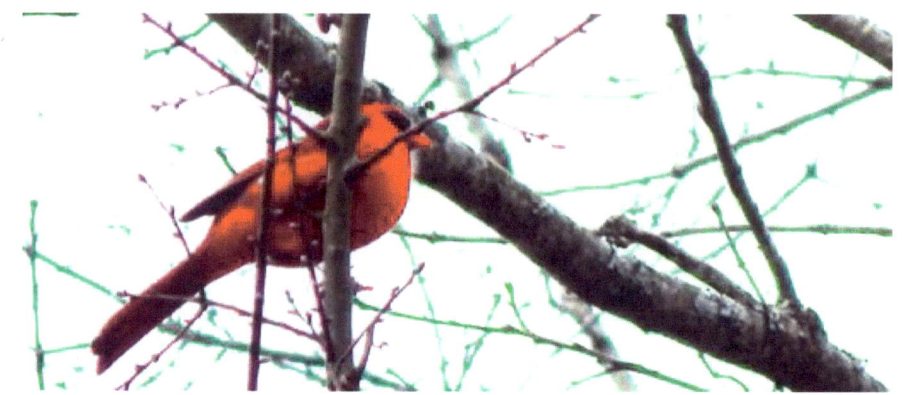

I'm sure no one will see me up here behind these red buds.

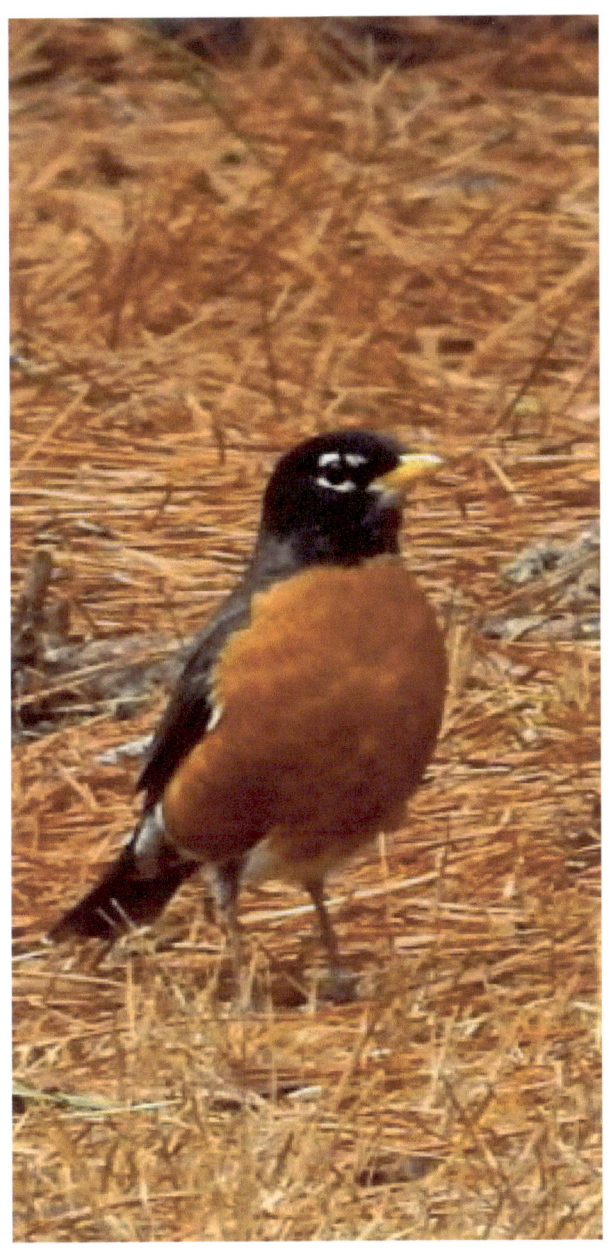

I tried some new eye shadow, but it's a little splotchy.

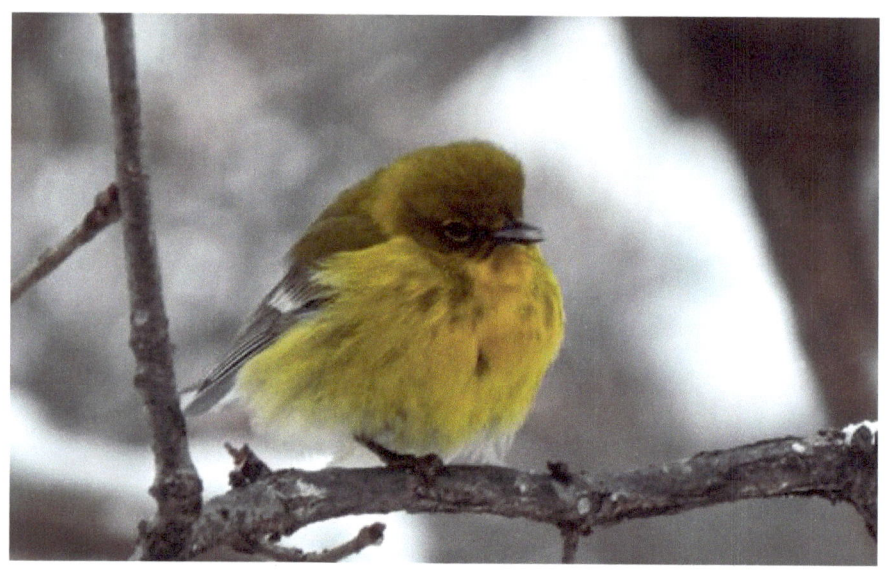

Back when I was a kid, we had to walk three miles to school every day–in the snow, up hill both ways.

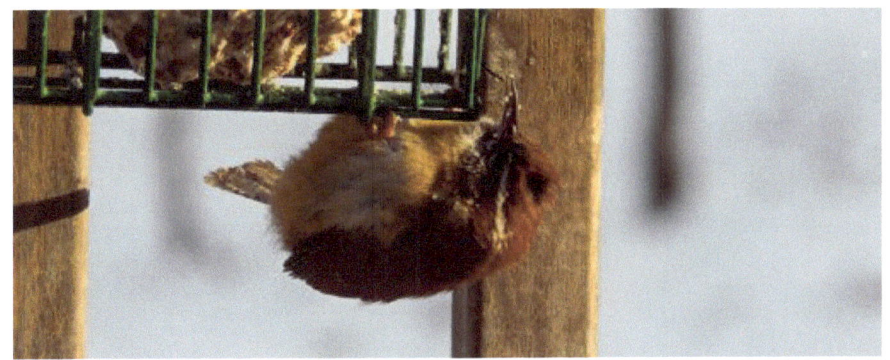

Nom, nom, nom, nom. . . .

You know I'd climb the highest branch for you, baby.

Well, you ugly too!

OK, on three, you go long, and you go short and make a button hook.

We all live in a Middle Georgia lake, a Middle Georgia lake, a Middle Georgia lake. ♫♪ ♪ ♩

You think we would've made some friends in the neighborhood by now, don't you think?

I miss her so much when she's gone.

Watch me twirl this stick. I'm good, huh?

If one of us had learned how to count, we could tell you how many of us there are here. But no one learned to count.

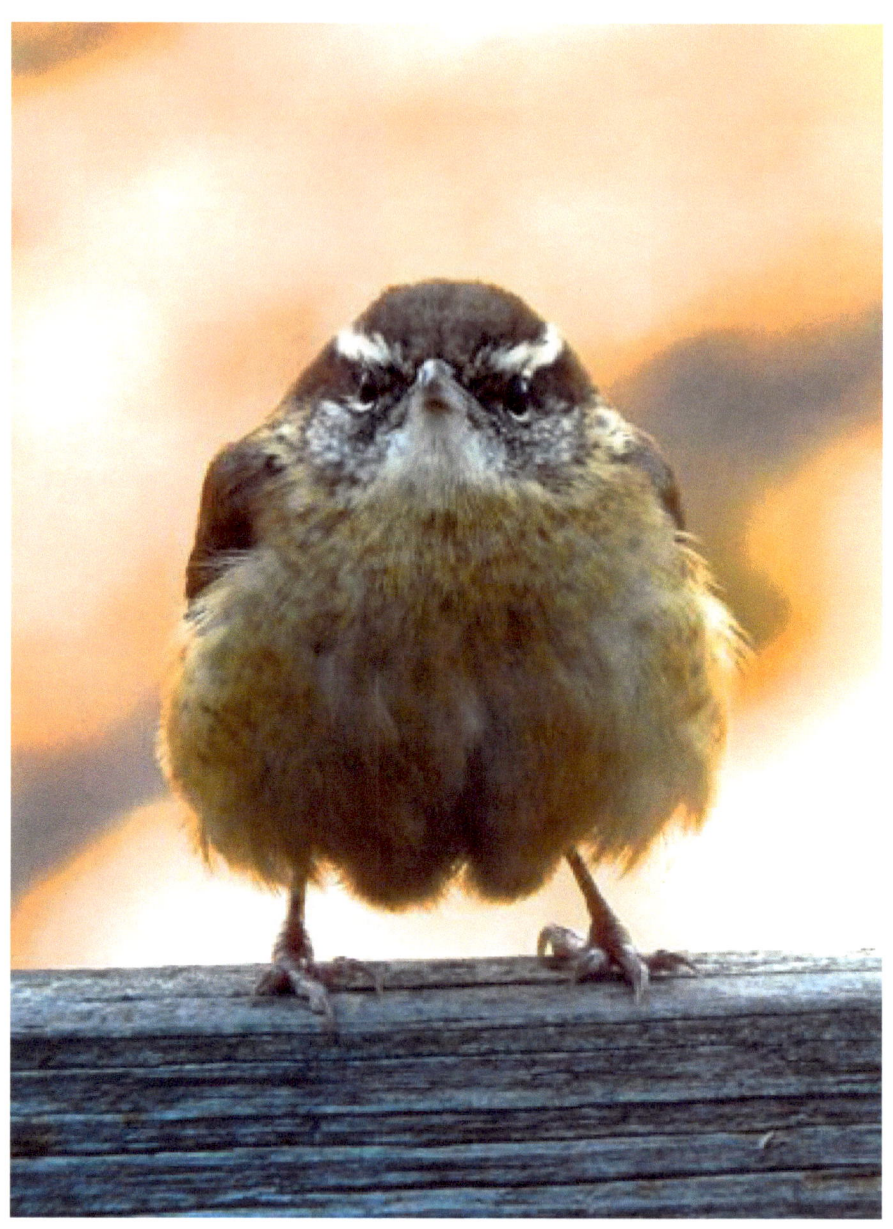

Quit smirking. We don't allow smirking.

www.ingramcontent.com/pod-product-compliance
Lightning Source LLC
Chambersburg PA
CBHW040843180526
45159CB00001B/293